MW00479856

60-SECOND
Refreshment

DAILY MESSAGES FROM
GOD'S HEART

60-SECOND
Refreshment

DAILY MESSAGES FROM GOD'S HEART

BARBOUR
PUBLISHING

© 2021 by Barbour Publishing, Inc.

ISBN 978-1-63609-038-2

Text originally appeared in *Today God Wants You to Know. . . Perpetual Calendar.*
Published by Barbour Publishing.

Published by Barbour Publishing, 1810 Barbour Drive, Uhrichsville, Ohio 44683,
www.barbourbooks.com

Our mission is to inspire the world with the life-changing message of the Bible.

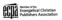

Printed in China.

WE'RE ALL PRESSED FOR TIME. BUT SOMEWHERE IN OUR DAILY SCHEDULE, THERE MUST BE AT LEAST SIXTY FREE SECONDS.

You're a wonder woman, balancing every area of your life—home, work, ministry. . .the list goes on. The hours are long, but the days are still too short to get everything accomplished. And time spent with your heavenly Father is usually the one thing that is left unchecked on your daily to-do list.

The Father knows what it is to be busy, and He understands the stress we feel when our schedules are bursting at the seams. Even when we don't take the time to hear His voice, He's still there—encouraging and supporting us every step of the way.

These encouraging mini readings come to you straight from the Father Himself. Make it a priority to meet Him every day in His Word, through a devotional thought, and in prayer. Even on the days you feel like you don't have a second to spare, dedicate a few moments to let Him know what's on your heart. He'll bless the rest of your day immeasurably. That's a promise you can count on.

Day 1
YOU ARE LOVED.

Think of it: unconditional love! Before God created you, He loved you. After He created you, He continued to love you, no matter what. He has placed love in your life that you can give and receive—family, friends, coworkers, neighbors. Love because you are loved today.

Day 2
GOD HAS GREAT PLANS FOR YOUR LIFE!

Today might seem like a dead end, but God promises He's got it under control—today, tomorrow, and forever. "'For I know the plans I have for you,' declares the LORD, 'plans to prosper you and not to harm you, plans to give you hope and a future'" (Jeremiah 29:11).

Day 3

YOU DON'T HAVE TO DEAL WITH YOUR STRUGGLES ALONE.

We look at our burdens and heavy loads and shrink from them; but as we lift them and bind them with our hearts, they become wings; and on them we rise and soar toward God.

MRS. CHARLES E. COWMAN

Day 4

YOU ARE NOT RULED BY YOUR PERSONALITY.

Have you ever blamed something on your personality—maybe an outburst of temper or a tendency toward laziness? It's time to stop playing the blame game. We were all created with unique personalities, but they do not define us.

Day 5
CHAINS CAN BE BROKEN IN YOUR LIFE.

Sometimes it feels like we're stuck, bound up by the chains of the past. There's good news today! God is in the chain-breaking business. Ask Him to set you free from the things that have held you bound, then watch as those chains are broken.

Day 6
YOU HAVE GREAT HOPE.

Imagine a burglar broke into your home and stole your television or perhaps your computer. You would feel violated of course. Many things can be stolen from us, but no one can take away our hope. We can cling fast to it, even when everything else crumbles.

Day 7
YOU CAN TOSS YOUR CARES OVERBOARD.

Ever feel like your cares are weighing you down? Like they are an anchor? Today, God wants you to know that you can toss those anchors overboard! Get rid of them. See them sinking to the bottom of the sea of forgetfulness.

Day 8
YOU CAN HAVE AN
IMPACT ON YOUR WORLD.

Did you know that you can make a difference in the lives of those around you? It's true! With a kind word or a smile, you can impact your world for the better. Today, step out of your comfort zone. Make an impact.

Day 9
YOU ARE FEARFULLY AND WONDERFULLY MADE.

Ever dislike what you see in the mirror? Find yourself being critical of your appearance? God didn't make a mistake when He picked out your nose, your hair color, or your physique. He knew just what He was doing in fact. So, instead of struggling with your looks. . . celebrate them! You are fearfully and wonderfully made.

Day 10
YOU ARE WORTH THE INVESTMENT.

Do you ever wonder about your value? No need! You are the most valuable thing in the world to God, and you are worth His investment.

Day 11
ROUGH RELATIONSHIPS REALLY CAN GET BETTER.

Struggling through a tough relationship? Ready to give up? Don't! Rough relationships can be mended. Consider using these twelve words, which could heal any relationship: I love you. I was wrong. I am sorry. Please forgive me.

Day 12

SOMETIMES BEING
IDLE IS A GOOD THING.

As Henry Wadsworth Longfellow once said, to "sit in reverie and watch the changing color of the waves that break upon the idle seashore of the mind" can be a lovely thing. Today, spend a little time resting and relaxing.

Day 13

A BAD HAIR DAY DOESN'T HAVE TO MEAN A BAD DAY.

Ever had a really bad hair day. . . a day when nothing seemed to be going right? Even on the toughest day, you can still keep a cheerful countenance. Folks will be so intrigued by your happy expression that they won't even notice your hair.

Day 14

THERE IS A PEACE THAT PASSES UNDERSTANDING.

If you've ever walked through a really rough season, you know how it can affect your nerves. Today, God wants you to know that He can give you a peace that passes understanding, even when you're going through a rough spell. Lean on Him. Breathe deeply. Feel His peace.

Day 15
ONLY BELIEVE.

I believe in the sun, even when it is not shining. I believe in love, even when I do not feel it. I believe in God, even when He is silent.

<div align="right">UNKNOWN</div>

Day 16

GOD IS INTERESTED IN WHAT YOU'RE GOING THROUGH.

Ever feel like no one's paying attention? Like you're going through life completely unnoticed? There is One who is paying close attention, and He's genuinely interested in what you're going through today. Spend time with Him. Listen to His words of love spoken over you.

Day 17

PRAYER IS THE MAIN WORK.

Many of us work from sunup till sundown. We slave away, motivated and driven. However, we often overlook the one "work" that really makes a difference: prayer. Today, make a decision to pray like you've never prayed before.

Day 18

YOU REALLY CAN WHISTLE WHILE YOU WORK.

Remember the song that the seven dwarves sang? They whistled while they worked, and it eased the workload. The song might have originated in a fairy tale, but the concept is very true. You really can enjoy your work by adding a little tune.

Day 19

THERE ARE NO
TEARS IN HEAVEN.

Life is filled with heartbreaking moments. Isn't it consoling to know that there will be no tears in heaven? No pain. No heartbreak. No anguish. Heaven will be a place of joy and celebration. What a glorious place that will be!

Day 20
BE STILL.

Learning how to be still, to really be
still and let life happen—that stillness
becomes a radiance.

MORGAN FREEMAN

Day 21
GOD IS WITH YOU WHEREVER YOU GO.

Ever feel like you've wandered too far?
Like God can't find you? Today, He
wants you to know that He's with you,
no matter where you go. If you climb
to the top of a mountain, He's there. If
you're in a low place, He's right there
beside you.

Day 22

BE A FIRST-RATE VERSION OF YOURSELF.

How many times do we try to fit in. . . to be like others? Being yourself—even if you're unique, quirky, or offbeat—is always best. Instead of trying to be like someone in your peer group, strive to be the very best you that you can be.

Day 23
YOU ARE NEEDED AND WANTED.

We all go through seasons in our lives where we feel left out or unwanted. Here's good news: you are always needed and wanted by the Lord. He will never leave you or forsake you, and He loves you with an eternal love.

Day 24
GOD WON'T LET YOU DOWN.

Ever been disappointed by someone you thought you could trust? You're certainly not alone. Today, God wants you to know that you can trust Him. He won't let you down. . .*ever*. So take a deep breath. You can rest easy, knowing He's on your side.

Day 25

A CRISIS ISN'T A CRISIS TO GOD.

When we go through an earth-shaking time, we're usually caught off guard. God isn't shaken though. He knew this was coming and has a plan to see you through. Trust Him in the middle of the crisis. Don't let go.

Day 26

IT'S OKAY TO BE AT A LOSS FOR WORDS.

God understands our prayers even when we can't find the words to say them.

UNKNOWN

Day 27
HE LOVES TO SURPRISE HIS KIDS.

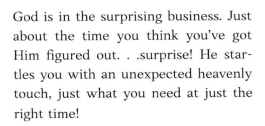

God is in the surprising business. Just about the time you think you've got Him figured out. . .surprise! He startles you with an unexpected heavenly touch, just what you need at just the right time!

Day 28
ALL ACHIEVEMENTS BEGIN AS AN IDEA.

Did you ever think about the fact that your ideas and plans come from above? Many are divinely inspired. Today, God wants to encourage you to act on those God-given ideas. Watch as those ideas morph into reality.

Day 29
GOD IS NEAR.

It might seem like God is far away, but He's not. He's closer than your closest friend and will stick with you when others fail you.

Day 30
YOU'VE ALREADY MADE A LOT OF PROGRESS.

Ever feel like giving up? Like the journey is just too hard? Instead of focusing on the road ahead, take a quick glance back. Look how far you've come! Once you see the distance you've already traveled, the road ahead won't look so daunting.

Day 31
DON'T GET ALL SHOOK UP!

Man's extremity is God's opportunity. Unshakable faith is faith that has been shaken.

UNKNOWN

Day 32
WHERE HE GUIDES,
HE PROVIDES.

God wouldn't lead you somewhere only to leave you barren and destitute in that place. He has a plan for your success and is guiding you even now. Just listen, then follow.

Day 33

LIFE IS SO MUCH MORE THAN WHAT YOUR EYES CAN SEE.

Ever wish you had bionic vision? That you could see beyond today's circumstances? God is working in amazing ways. Oh, if only you could catch a glimpse of what's going on in the heaven right now!

Day 34
GETTING YOUR WAY IS NOT ALWAYS FOR THE BEST.

Are you accustomed to getting your own way? Do you struggle with a "me first" mentality? If so, it's time to let that go. Putting others first is God's way. Sure, it's not always easy, but it's always right.

Day 35

WHAT REALLY MATTERS IS WHAT HAPPENS IN US, NOT TO US.

Most of us go through rough seasons in our lives, seasons when unfair things happen. Sometimes we let those seasons define us. It's time to change the way we see ourselves. What happens in us is far more important than what happens to us. What's happening in you today?

Day 36

JOY IS CONTAGIOUS.

Have you ever been in a room where someone started laughing? Before long, the next person was laughing. . . and then the next. Just about the time you thought you could contain your giggles, out they came! Don't fight it. Let the joy flow!

Day 37

YOU CAN TRIUMPH OVER HARDSHIP.

Many people go through hardships and never recover. They end up coiled up in a ball, tightly wound (and bound) by the pain. Hardship doesn't have to end this way. You were created to triumph even over the toughest things. Today, begin to see yourself as a victor.

Day 38
WHEN YOU BLESS OTHERS, YOU'VE BLESSED THE LORD.

Did you know that giving a cup of cold water to a stranger is like giving water to God Himself? It's true! "The King will reply, 'Truly I tell you, whatever you did for one of the least of these brothers and sisters of mine, you did for me' " (Matthew 25:40).

Day 39

SOMETIMES WE HAVE TO GO PLACES WE DON'T WANT TO GO.

Ever had that "I don't want to go there" attitude? We're often called to go places—physically, emotionally, spiritually—that we don't want to go. Only on the other side of the journey do we realize the significance. Don't be afraid. Go.

Day 40
YOU CAN PERSEVERE.

Patience and perseverance have a magical effect before which difficulties disappear and obstacles vanish. A little knowledge that acts is worth infinitely more than much knowledge that is idle.

JOHN QUINCY ADAMS

Day 41
IT MIGHT BE TIME FOR AN "I" EXAM.

Today, God wants you to spend the day noticing how many times you start a sentence with the words "I," "me," and "my." Perhaps it's time to shift your focus.

Day 42
THERE IS REST FOR THE WEARY.

Do you ever feel so exhausted that you can't sleep? If so, you're not alone. People all over the globe have worked themselves into a sleepless frenzy. Thank goodness, there is a rest for the weary. . .and it's a deep-rooted rest, one found only in the Lord.

Day 43
LIFE REALLY DOES HAVE
A BACKSPACE KEY.

Oy, those mistakes! We make so many of them! If you're like most people, you want to slink away and hide after messing up. Thank goodness, life really does have a backspace key. When you ask the Lord to forgive the mess-ups of the past, He erases them. They're gone. . .forever!

Day 44
LIFE IS MORE THAN EXISTING.

Ever feel like you're just existing? Just holding on? Today, God wants you to know that you can have abundant life—life that is adventurous, exciting, and filled with new destinations. There's so much more out there for you. Why just exist when you can really live?

Day 45
IT'S NOT ABOUT THE MONEY.

Many people make the mistake of thinking that all the challenges in their lives would dissipate if they just had enough money. Nothing could be further from the truth. Earning more money, in and of itself, rarely frees people.

ANTHONY ROBBINS

Day 46

HE WANTS TO CLEAN OUT YOUR CLOSETS.

Ever spend a day clearing out your closet? Likely you ditched the clothes and shoes that didn't fit, then spent some time reorganizing. There are times when we need to take inventory of our "soul closets." We allow condemning thoughts or bitterness to take root in our soul. Time to clean that mess up!

Day 47

BETWEEN YESTERDAY AND TOMORROW, YOU CAN FIND PEACE.

When you're worried about tomorrow, it's hard to be peaceful. And when you refuse to let go of the pain of yesterday, true, lasting peace never comes. The very best place to find peace—real, lasting peace—is by living in today.

Day 48
A CLEAR CONSCIENCE MAKES A SOFT PILLOW.

Guilt can keep us awake nights, no doubt about it. Today, if you're struggling with guilt, ask the Lord to forgive you for what you've done, then hand it to Him. Once you've dealt with it, you'll sleep like a baby.

Day 49

YOUR LIFE IS A MOVIE THAT OTHERS ARE WATCHING.

And now, starring in the role of a lifetime. . .you! Yes, you! Your life is really a movie that others—friends, family members, church members, teachers, children, and so forth—are watching. What sort of performance are you giving them? One that will take home the prize?

Day 50
YOU CAN REACH GREAT HEIGHTS.

The heights by great men reached and kept were not obtained by sudden flight. But they, while their companions slept, were toiling upward in the night.

Thomas S. Monson

Day 51
THE GIFTS INSIDE OF YOU ARE MEANT TO BE SHARED.

Imagine you had a wonderful Christmas gift for a friend. You gave it to her and watched as she took a peek inside, then laid it aside. Surely that's how God feels when we don't utilize the gifts He's given us. Take those gifts out! Show them off. Use them to share joy with everyone you meet.

Day 52
THERE ARE PAGES OF YOUR LIFE NOT YET WRITTEN.

Sometimes it's fun to think of your life as a novel that's only partially written. What chapter are you on? How many chapters are behind you? How many are in front of you? Today, the Lord wants you to know that the upcoming chapters in your life's story are going to be filled with His goodness and mercy.

Day 53
YOUR TRANSFORMATION WILL CHANGE OTHERS.

Perhaps you've heard the old expression "Changed lives change lives." It's so true. When you've been through a transformation—physical, emotional, spiritual, or otherwise—you want to shout it from the rooftops, and others are sure to respond.

Day 54

ASK AND IT WILL BE GIVEN TO YOU.

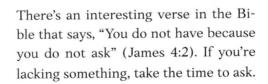

There's an interesting verse in the Bible that says, "You do not have because you do not ask" (James 4:2). If you're lacking something, take the time to ask.

Day 55

AIM ABOVE THE MARK. YOU'LL COME CLOSER TO HITTING IT.

Ever have that "just getting by" mentality? You swing low, then wonder why you don't hit the mark? Today, go out of your way to aim high. You might just be surprised at what you hit!

Day 56
OPPORTUNITIES ARE
OFTEN DISGUISED.

We are all faced with a series of great opportunities brilliantly disguised as impossible situations.

CHARLES R. SWINDOLL

Day 57

YOU DISCOVER WHO YOU ARE
THROUGH LIFE'S CHALLENGES.

Want to find out who you really are?
Want to know if you've got the goods?
Try going through a few challenges.
There's nothing like a little time in the
fire to find out if you can survive the
purification process.

Day 58
YOU HAVE GOD-GIVEN GIFTS AND ABILITIES.

Did you know that your talents come from God? Sure, you can practice at the piano, but He gave you the desire to play in the first place. Sure, you can practice those ballet moves, but He put the desire to dance inside of you!

Day 59
DON'T BELIEVE THE LIES THAT HAVE BEEN SPOKEN TO YOU.

Perhaps you've been lied to. You've been told dozens—or even hundreds—of things about yourself that simply aren't true. Maybe you've believed those lies, not knowing the difference. Today, the Lord wants you to know that a lie is a lie. Don't believe it! Break its hold over you!

Day 60
GOD IS PLEASED TO CALL YOU HIS CHILD.

Parents know the joy of saying, "This is my little girl!" or "This is my little boy." We're so proud to claim our children. (Until they get to their teens, anyway!) Doesn't it make you smile to know that God is pleased to say, "This one is Mine! I adore them!"

Day 61

LEARN TO LAUGH AT YOURSELF.

Laughing at our mistakes can lengthen our own life. Laughing at someone else's can shorten it.

CULLEN HIGHTOWER

Day 62

SOMETIMES IT COSTS MORE TO DO NOTHING THAN TO DO SOMETHING.

Have you ever considered the fact that apathy is expensive? It's true. Doing nothing can be very costly—to your relationships, your career, even your emotional and spiritual state. The next time you feel the nudge to do something. . .get busy!

Day 63
PATIENCE IS THE COMPANION OF WISDOM.

If you've ever met a truly wise person, then you probably notice that he has a higher patience level than most. Patience walks hand-in-hand with wisdom. So, how's your patience level today? Before you claim to be wise, take a second look. Patience, my friend! Patience!

Day 64
GOD DOESN'T LOOK AT THE OUTWARD APPEARANCE.

Aren't you glad God doesn't pay attention to your outward appearance? He's not standing nearby to critique your hairstyle, skin color, weight, or height. Instead, His penetrating gaze is directed at something you can't see—your heart.

Day 65
THE BATTLE BELONGS TO THE LORD.

If you're facing a formidable foe today, remember, the battle isn't yours to fight. It never was. Suit up in your armor, but trust the Lord to win the battle on your behalf.

Day 66

THERE'S PEACE IN THE MIDDLE.

Having spent the better part of my life trying to either relive the past or experience the future before it arrives, I have come to believe that in between these two extremes is peace.

UNKNOWN

Day 67
GOD CAN USE YOU, NO MATTER YOUR CIRCUMSTANCES.

Maybe you think your background—where you've come from—limits you from being used by God to do mighty things. Nothing could be further from the truth! All of the great men and women of the Bible had a "past." Aren't you glad that God chooses people to impact the world according to His criteria not ours?

Day 68
THE BEST WAY TO HAVE THE LAST WORD IS TO APOLOGIZE.

Oh, how we love to have the last word! We clench our fists, ready with a comeback, even before the other person finishes speaking. Today, take a deep breath. Consider apologizing even if you don't feel at fault. That way, you'll always have the last word.

Day 69
GOD PLUS ONE EQUALS A MAJORITY.

When you take the time to pray before making decisions, you can move forward with the assurance that God is right there, guiding you all the way. Even if no one else chooses to go along for the ride, you are not alone. And remember, even if you feel alone, God plus one equals a majority.

Day 70
HE'S READY FOR AN INSTANT MESSAGE. . .RIGHT NOW!

We live in an "instant" world, don't we? Text messages, instant message, social networking—everything is so quick. Today, God wants you to know that He's standing by, ready for an "instant" encounter with you.

Day 71
FREEDOM OF RELIGION COMES AT GREAT COST.

Likely you've heard the expression "Freedom isn't free." It comes at great cost to those who risk their lives to protect it. Today, as you contemplate your religious freedom, take the time to pray for those who've made it possible.

Day 72
CHILDREN NEED
TO FEEL CHERISHED.

Children will not remember you for the material things you provided but for the feeling that you cherished them.

RICHARD L. EVANS

Day 73
YOU DON'T NEED TO RELY ON YOURSELF FOR ENERGY.

These days, people all over the world feel zapped of energy. They drink energy drinks, hoping to "pep up" their levels. If you want a lasting dose of energy, go to the real supplier—the Lord. He can energize you and give you the zeal to face life's challenges.

Day 74
ROME WASN'T BUILT IN A DAY.

We're always in such a hurry, aren't we? It's hard to remember that not everything happens at once. Some things require time, patience, and great effort. Instead of rushing toward the goal, step back and take a look at the details. Then inch your way forward, building brick by brick.

Day 75
THESE ARE THE GOOD OLD DAYS.

People are always asking about the good old days. I say, why don't you say the good *now* days?

<div align="right">Robert M. Young</div>

Day 76

GOD DOESN'T HAVE AN AX TO GRIND WITH YOU.

Some people wander away from the Lord then refuse to come back because they think He'll be mad at them. Nothing could be further from the truth! God has no ax to grind with you even if you've wandered from the fold. He longs for you to come back home so that He can sweep you into His arms.

Day 77

THERE'S A TIME TO STOP TALKING AND JUST LISTEN.

Oh, how we love to get a word in edgewise even if it means interrupting someone to do so. After all, our opinion is valuable. . .right? Today, God wants you to know that listening is a specialized skill. Not everyone does it well, but He longs for you to try.

Day 78

GOD REALLY CARES ABOUT YOUR ACHY-BREAKY HEART.

If you've walked through a particularly rough relationship or have experienced a broken heart, the Lord cares a great deal. He longs for you to get past the pain and learn to trust again.

Day 79
MANY HANDS MAKE LIGHT WORK.

Don't you love working alongside others? There's something so wonderful about joining with friends to get a job done. The task is lighter, the conversation is cheerful, and the result is a job well done.

Day 80

IT'S NOT GOOD FOR ALL
OF OUR WISHES TO COME TRUE.

It is not good for all our wishes to be fulfilled; through sickness, we recognize the value of health; through evil, the value of good; through hunger, the value of food; through exertion, the value of rest.

GREEK PROVERB

Day 81
YOU ARE THE
APPLE OF GOD'S EYE.

Likely you've heard the expression "She's the apple of her father's eye." Even if you didn't have a great relationship with your earthly father, God wants you to know that you're the apple of His eye. His heart swells with joy when He thinks about you.

Day 82
YOU ARE A WORK IN PROGRESS.

We get frustrated when we don't see the kind of progress in our lives that we hope for. We want to rush the process. Remember, you are a work in progress! Inch by inch, mile by mile. . . you're growing.

Day 83
A HUG IS A GREAT GIFT!

Doesn't it feel great to have someone wrap their arms around you and tell you that everything is going to be okay? Today, you can be that someone. Wrap your arms around a friend and whisper in her ear, "Everything is going to be fine."

Day 84
YOU CAN CRAWL UP
INTO YOUR DADDY'S LAP.

If you had a good relationship with your father when you were a child, perhaps you remember crawling up into his lap, leaning your head on his shoulder, and listening to him tell you a story. Your Daddy God longs for you to crawl up in His lap today. He has much to tell you!

Day 85

NO MAN IS RICH ENOUGH
TO BUY BACK HIS PAST.

Aren't you glad the past is behind you? Greater still, it's never coming back. All of those mistakes of yesterday. . .they're dead and gone. Even if you owned every bank in town, you couldn't buy back your yesterdays.

Day 86
CHILDREN AROUND THE GLOBE NEED YOUR LOVE.

Sometimes we get so caught up in the day-to-day grind that we forget the needs of children around the globe. If you've never considered sponsoring a child or supporting a foreign missionary, perhaps today is your day!

Day 87
GOD IS NOT A LIAR.

If you're like most people, you've been lied to. It hurts, doesn't it? And it breaks trust. Once that person lies to you, it's harder to believe him the next time. Aren't you glad God isn't a liar? If He said it. . .He'll do it!

Day 88

DISAGREEABLE PEOPLE CAN BE WON OVER WITH A SMILE.

When you come in contact with a cranky person, how do you respond? Does their crankiness rub off on you? Truth is, even cranky, bitter people respond better to honey than vinegar. You're much more likely to see a sticky situation turned around with a smile than a frown.

Day 89
THE LORD WATCHES OVER YOUR COMINGS AND GOINGS.

We rush out the door to work then buzz down the road, radio blaring. We stop off at the store then run by a friend's house before going home at night. All along the way, the Lord has His eye on us. We're never out of His sight. His love for us is so deep that He just can't take His eyes off of us!

Day 90
YOU CAN TAKE ACTION TODAY.

Been feeling stuck? Got your feet in the mud? Even if your situation has held you captive, this is your day to break free. Take action. Make a move. Don't hold back. Step forward. . .and watch God work.

Day 91
BROKEN HEARTS CAN
BECOME BRAND NEW.

The pain of a broken heart can be devastating. Crushing, even. Isn't it good to know the Lord is in the heart-mending business? He can take that broken heart and breathe new life into it, making it even better than new.

Day 92

THE FIRST WILL BE LAST
AND THE LAST WILL BE FIRST.

Some things in life just don't seem fair. Oftentimes people are elevated—at work, in sports, with their artistic gifts—and we feel left behind. Doesn't it make you feel good to know that the first will be last and the last will be first? Even if you've been lagging at the end of the line, your day is coming!

Day 93
MORNING IS COMING.

We go through seasons where it feels like someone turned out the light. Everything is dark. Dreary. We can't seem to get past the pain that comes with the night. Today, God wants you to know that morning is coming. There will be a bright, new sunrise, and all of the pain you've faced in the night will fade away like the morning dew.

Day 94

WITH GOD ON YOUR SIDE, YOU CAN BE BOLD AND COURAGEOUS.

Are you the timid sort? Afraid to speak your mind? Shiver and shake when you think of standing in front of people? There's good news! The same God who gave David the courage to take down the mighty Goliath stands ready to embolden you with courage too!

Day 95
YOU ARE CALLED, CHOSEN, AND SET APART.

Before the foundation of time, God knew your name. He chose you for Himself. Isn't that an amazing thought? Before the planet was formed, God was thinking of you!

Day 96

GOD'S IDEA OF SUCCESS MIGHT BE DIFFERENT FROM YOURS.

We all have such unique ideas about success. To some, it's a large bank account or a big house. To many, it's landing the perfect job. Today, God wants you to know that His definition of success has nothing to do with those things. He's far more interested in your heart than your fancy car.

Day 97

THE BEAUTY OF CREATION IS ALL AROUND YOU.

What a perfect day to stop and look around you. Enjoy the beauty of creation. The trees. Wide-open fields. Mountains. Rivers. Streams. Crisp, fallen leaves. Budding flowers. How often do we drive right past these things and never see them? Creation beckons!

Day 98

HE LOVES IT WHEN YOU SET APART A DAY TO WORSHIP HIM.

We worship God every day of the week. Some people would say that worshipping alone—apart from others—suits them just fine. But there's something about coming together with other believers that strengthens us and brings great joy to the heart of God.

Day 99

GOD CAN HELP YOU AT THE FORK IN THE ROAD.

Sometimes life presents us with "eenie-meenie-miney-moe" moments. We stand at a proverbial fork in the road and have no idea which way to turn. We're hesitant to move forward for fear of making a mistake. Just remember, God is standing right there alongside us, whispering, "Turn this way!"

Day 100
COMMON SENSE IS
NOT ALWAYS COMMON.

Have you ever met someone who's book smart but doesn't seem to have common sense? No matter how many degrees you have, nothing can take the place of good old common sense.

Day 101

WHEN YOU TRUST GOD, HE MAKES YOUR PATH STRAIGHT.

Ever set off on a path only to find yourself going down a rabbit trail? You accidentally turn off then find yourself lost? It happens all the time. Thank goodness the Lord has a way of wooing you back to the right road. Listen closely! He's giving you instructions even now.

Day 102

YOU HAVE A FATHER WHO WILL NEVER LEAVE YOU.

If you've ever known the pain of rejection by an earthly father then perhaps you have a hard time relating to God as a father figure. Today, He wants you to know that—no matter how much rejection you've faced in the past—He will never leave you or forsake you.

Day 103

FALLING OFF THE WAGON
ISN'T THE END OF THE ROAD.

We all make mistakes. We all fall. Sometimes we stumble in private, where no one sees us. Other times, we crater in front of a crowd. Even if you've messed up in a huge (or public) way, take heart. You can begin again. Stand up. Brush yourself off. Keep on keepin' on.

Day 104
IT IS POSSIBLE TO RENEW YOUR MIND.

Ever wish you could clear your mind of all the junk? Need an overhaul of your thought-life? With God's help, you really can erase the bad and replace it with good. Your mind—and your heart—can be renewed (just like new). All you have to do is ask.

Day 105
YOU CAN GO ON LEARNING, NO MATTER YOUR AGE.

It doesn't matter if you're two or ninety-two, it's never too late to learn. Staying on a learning curve will keep you sharp, alert, and aware of what's going on around you. Today, make up your mind to be a perpetual student.

Day 106

GOD IS THE POTTER,
WE ARE THE CLAY.

Ever try to shape yourself into someone you're not just to impress people? Today, God wants you to know that He's the one doing the shaping. We're the clay. He's the one with hands extended, molding us into His image.

Day 107
MOTIVES MATTER.

Ever do a "motives" check? Truth is, we often do good things with bad motives. It's time to check your motivation. Why are you doing what you're doing (good or bad)? Be honest! If your motivations are self-focused, it's time for a little self-evaluation.

Day 108

YOUR SINS WON'T KEEP HIM FROM HANGING OUT WITH YOU.

Ever do something so bad that people didn't want to be around you? There's good news today: God won't ever abandon you even when you mess up in a huge way. He will stick around even when others don't.

Day 109
CHOOSE YOUR ATTITUDE!

The remarkable thing is we have a choice every day regarding the attitude we will embrace for that day. . . . I am convinced that life is **10 percent** what happens to me and **90 percent** how I react to it. And so it is with you . . .we are in charge of our attitudes.

CHARLES SWINDOLL

Day 110
GOD IS NEVER LATE.

Sometimes it seems like we serve an eleventh-hour God. He waits to come through till the very last minute. Truth is, it just seems that way. God's timing is always perfect, and He's never, ever late.

Day 111
PROSPERITY ISN'T JUST ABOUT MONEY.

When you hear the word *prosperity,* you likely think of money. There are many other ways to prosper, however. Our souls can prosper. Our health. Our relationships. Our careers. Anything that we place in God's hands will thrive (and prosper).

Day 112
GOD'S WAY IS THE HIGH WAY.

It's not always easy to take the high road, is it? This is especially true if we've been falsely accused or wounded in some sort of way. Still, God's way is the high way, so step up! Do the right thing. . .even in hard circumstances.

Day 113

YOU REALLY CAN VIEW LIFE FROM THE SUNNY SIDE.

Perspective is everything! Some people see the glass half full; others, half empty. Some wear a smile even when they're going through a storm; others brood when the skies are sunny. Today, God wants you to know that viewing life from the sunny side will keep your heart lifted.

Day 114
YOU CAN DO MORE
THAN YOU THINK.

You gain strength, courage, and confidence by every experience in which you really stop to look fear in the face. You must do the thing which you think you cannot do.

ELEANOR ROOSEVELT

Day 115

HE SEES YOUR TEARS. . .
AND HE CARES.

We go through a lot of valleys, don't we? And sometimes it feels like we're all alone in our pain. The tears flow, but no one seems to notice. Oh, but Someone does notice! God sees those tears. . .and He cares. In fact, His heart breaks alongside yours. Today, He longs for you to know you're not alone in the valley.

Day 116

FAILURE IS AN EVENT
NOT A PERSON.

Have you ever called yourself a failure? Perhaps someone else put that label on you. Here's the truth: People aren't failures. Failure is an event— something that happens. It's not a person. No matter how many times you mess up, you will never be a failure.

Day 117

LOOK OUT FOR SERENDIPITOUS MOMENTS.

Serendipitous moments happen all the time. We "just happen" to run into someone then end up falling in love. We "just happen" to get a check in the mail on the very day we were praying for a financial miracle. God loves to surprise us with those serendipitous moments!

Day 118

TOMORROW, TODAY WILL BE BEHIND YOU.

Having a bad day? Ready to get it behind you? It will be gone sooner than you think. Tomorrow, today will be nothing more than a hazy yesterday.

Day 119

INPUT AND OUTPUT AREN'T JUST COMPUTER TERMS.

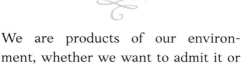

We are products of our environment, whether we want to admit it or not. What we put in eventually comes out. That's why it's so important to "input" good things (good attitudes, good words, good thoughts) because they will surely come out for all to see!

Day 120

THE HARD STUFF IS MADE HARDER WHEN YOU ADD ANXIETY.

Life is hard enough without adding stress. Oh, we don't mean to. We don't set out to let anxiety rule the day. But one thing leads to another and before long we're unraveling at the seams. Today, make up your mind not to add stress to whatever problems you're facing.

Day 121

LIFE IS FULL OF NEW BEGINNINGS.

Fresh starts! New beginnings! Oh, how wonderful they are. If you feel like you've been stuck—like beginning again is impossible—there's good news today! You have the opportunity to start fresh.

Day 122

YOU ARE MORE VALUABLE TO GOD THAN ALL OF CREATION.

Think about it! The sun, the moon, the stars. . .snowcapped mountains, a field of flowers, a majestic ocean. In God's eyes, you are far more valuable than all of them put together!

Day 123

KEEP RUNNING EVEN WHEN YOU CAN'T SEE THE FINISH LINE.

Ever feel like you're running a marathon? The finish line is so far off in the distance that you can't even see it? That's part of the journey. . .trusting God to guide you until the finish line is in sight. So keep running!

Day 124

COURAGE AND WISDOM
WALK HAND IN HAND.

Courage is what it takes to stand up
and speak; courage is also what it takes
to sit down and listen.

WINSTON CHURCHILL

Day 125
GREATER THINGS ARE COMING.

Many people believe their best days are behind them. Today, the Lord wants you to know that He's got great plans for you. No matter how great yesterday was, tomorrow can be even better.

Day 126

THE TASKS HE PUTS IN FRONT OF YOU ARE DOABLE.

Have you ever been given an assignment that felt impossible? Maybe you're facing one now. Here's the good news: God won't put anything in your path unless He's confident it's doable. Lean on Him. Together, you will get the job done.

Day 127

YOUR SOUL CAN BE SATISFIED IN HIM.

We tend to get dissatisfied easily, don't we? We're easily bored. Our expectations are unrealistic. Today, God wants you to know that true satisfaction really is possible—your soul (heart, mind) can be satisfied in Him.

Day 128
FASTER IS NOT ALWAYS BETTER.

Maybe you're one of those people who tears through a project, moving as fast as you can. Remember, faster isn't always better. Slow and steady wins the race!

Day 129
KNOCK AND THE DOOR WILL BE OPENED.

Ever feel like doors are being slammed in your face? You don't have to live that way. Matthew 7:7 says: " 'Ask and it will be given to you; seek and you will find; knock and the door will be opened to you.' " Today, keep knocking.

Day 130

YOU HAVE A SHEPHERD
WHO CARES FOR YOU.

Ever feel like a little lost sheep? Wondering if the big, bad wolf is out to get you? Take heart! You have a Shepherd who cares for you and is watching over you to protect you.

Day 131
YOU CAN BE EXCITED ABOUT EACH NEW DAY!

Ever get that ho-hum feeling? Life just doesn't seem to have the same pizzazz it used to have? Today, God wants you to know that He can invigorate you for the journey ahead. You really can get excited about each new day!

Day 132

GIVING YOURSELF AWAY IS THE BEST WAY TO FIND YOURSELF.

Wondering how to find yourself? The very best way is to give yourself away. Care for the needs of others. Give of yourself. Feed the homeless. Share a meal with an elderly person. In doing so, you will surely find yourself.

Day 133

BEING RICH AND FAMOUS ISN'T THE ANSWER.

I think everybody should get rich and famous and do everything they ever dreamed of so they can see that it's not the answer.

JIM CARREY

Day 134

WITH A BIT OF FAITH YOU CAN MOVE MOUNTAINS.

Is there a mountain in your path? Something standing between you and your dream? You don't have to climb it. You don't have to tunnel through it. You don't have to trek around it. You just have to say to it "Mountain, get out of my way!"

Day 135
NOTHING IS IMPOSSIBLE FOR GOD.

How often do we use the words "That's impossible!" To us, many things seem out of the realm of possibility. Sometimes we forget that nothing is impossible for God!

Day 136

IF YOU'RE WEAK AND WEARY, GOD WILL GIVE YOU REST.

Ever been so tired you couldn't sleep? Rest eluded you? Thank goodness, these seasons don't go on forever. Take a deep breath and lean on God, who longs to give you the rest you need.

Day 137
YOU CAN NEVER OUTGIVE GOD.

Do you consider yourself a giver? You love to help other people out? Doesn't it feel good to help? If giving is your passion, then God smiles down on you. He's the greatest giver in the world! He gave you life, after all!

Day 138
YOU CAN BE A NEED-MEETER.

The place God calls you to is the place where your deep gladness and the world's deep need meet.

FREDERICK BUECHNER

Day 139

YOU CAN BE AS HAPPY AS YOU MAKE UP YOUR MIND TO BE.

Don't you just love people with a cheerful attitude? It's almost as if they've made up their minds to be happy, no matter what. Today, the Lord wants you to know that half the battle is in the attitude.

Day 140

GOD CAN GIVE YOU COURAGE EVEN WHEN YOU'RE AFRAID.

Some days we don't feel like putting one foot in front of the other. We face challenges so great that we're overwhelmed. When you walk with God, courage comes from a place deep within. He truly gives you the wherewithal for the journey.

Day 141

LIFE MUST BE LIVED FORWARDS.

Life can only be understood backwards; but it must be lived forwards.

SØREN KIERKEGAARD

Day 142
THE VICTORY IS YOURS!

We don't always feel victorious, do we? Sometimes we let discouragement take the upper hand. Victorious people have a different attitude. They feel victorious even when the battle hasn't been won yet. They see themselves as overcomers. What about you? How do you see yourself?

Day 143

YOU WERE MADE
FOR RELATIONSHIPS.

We were never meant to go it alone.
God created us to be in relationship
with others. Today, spend some time
thanking Him for the relationships
He's placed you in.

Day 144
YOUR REAL TREASURE ISN'T AT THE BANK.

If you're like most people, you would love to see your bank account grow over time. It's always a good idea to save up for a rainy day. However, God wants you to know that your real treasure isn't something that can be measured in dollars and cents. Your real treasure is waiting for you. . .in heaven.

Day 145
YOU ARE STRONGER THAN YOU THINK.

Some days we feel about as strong as a limp noodle. The energy has drained out of us. On those days, we have to rely on God, who is our ultimate strength. When we do, we find a renewed "zap" of energy and wherewithal. It's not a fake energy. Oh no! This is the real deal!

Day 146
YOU CAN BE STRENGTHENED BY JOY.

Did you know that joy is an energizer? It's true! When you choose joy (even in the tough circumstances), you'll find yourself invigorated with new, unexplainable strength!

Day 147

YOU'RE NOT A SURVIVOR. . .
YOU'RE A THRIVER!

Today, the Lord wants you to know that calling yourself a "survivor" isn't the whole truth. Even if you've been through some really tough stuff, you're more than a survivor. . .you're a thriver!

Day 148
THE FUTURE COMES
ONE DAY AT A TIME.

Sometimes we get in a hurry. We want tomorrow to come. . .today! Right now! We don't want to wait. The future is coming, but it's never in a hurry. It comes one day at a time, just as it has for thousands of years.

Day 149

FRESH AIR AND SUNSHINE ARE GOOD FOR THE SOUL.

If life is draining you, try stepping outside! There's something rather magical about fresh air and sunshine. The great outdoors can transport you beyond your daily woes to a place where birds are singing, clouds are transformed into characters, and the breeze feels like a heavenly song being played over you.

Day 150
NO ONE IS TOO GREAT TO SERVE.

Some people come across as high and mighty, don't they? Worse yet, they act like they're too good (or too important) to perform certain menial tasks. Today, God wants you to know that everyone—great and small—is called upon to serve.

Day 151
YOU CAN GET MAD
WITHOUT SINNING.

Did you know that getting angry isn't a sin? It's what you do with that anger that concerns God. If you find yourself angry, take a deep breath. It really is possible to let it go. . .before things get explosive!

Day 152

LIFE COMES IN SEASONS.

Nothing lasts forever. Think about that. No season—good or bad—lasts beyond its times. If you're facing a difficult challenge today, remember. . .it's just a season. This season will surely pass.

Day 153

SAIL AWAY FROM THE SAFE HARBOR.

Twenty years from now you will be more disappointed by the things you didn't do than by the ones you did. So throw off the bowlines, sail away from the safe harbor. Catch the trade winds in your sails. Explore. Dream. Discover.

MARK TWAIN

Day 154

GOD CARES ABOUT WHAT YOU'RE GOING THROUGH.

It's easy to imagine you're all alone in the world. . .that no one knows or cares what you're going through. Still, the Bible is clear on this one. God knows everything you're facing, and He cares.

Day 155

IT PLEASES GOD TO BLESS YOU.

If you're a parent, then you know that wonderful feeling of giving special gifts to your child. There's nothing like the look of wonder in a youngster's eyes on Christmas morning. Today, God wants you to know that He is a loving Father, and He gets great pleasure out of blessing His kids too.

Day 156

WHEN YOU ARE WEAK, HE IS STRONG.

Did you know it's okay to admit you're weak? There are truly times when it's better to say, "I can't handle this! I'm worn out!" than to pretend we're okay. In those times, we must rely on God, who longs to strengthen us from the inside out.

Day 157
PRIDE CAN ACT LIKE A POISON.

Ever meet someone who sounded (and felt) like poison? Pride (arrogance) can puff you up with a venom that affects everyone who comes in contact with you. Today, spend some time willfully letting go of all pride.

Day 158
WE CAN CELEBRATE
OUR UNIQUE GIFTS.

Ever feel like you're different from other people? The things that interest them don't interest you? Their talents and abilities are completely different from your own? Instead of trying to be like them, celebrate your unique talents and interests.

Day 159

GOD SPEAKS
THROUGH HIS WORD.

How many times have you said, "I wish God would just show me what to do!" or "Why doesn't He just speak to me?" Truth is, He speaks to you every time you open the Bible. His Word is loaded with instructions for everyday living.

Day 160
GOD HAS UNLIMITED
ANYTIME MINUTES.

Ever been in the middle of a call with someone who said, "I'd better hang up now. I'm almost out of minutes." Here's the good news: God is never out of minutes. He can chat with you 24/7 and you'll never hear the words, "Oops, I've got to go now!"

Day 161
OPTIMISM IS ESSENTIAL TO SUCCESS.

Optimism is essential to achievement and it is also the foundation of courage and true progress.

NICHOLAS MURRAY BUTLER

Day 162

THE TRUTH WILL SET YOU FREE.

Sometimes the truth is hard to hear. It's painful. Still, difficult truth is always better than a lie. Today, make up your mind to tell the truth and to receive the truth.

Day 163
HOLDING YOUR TONGUE
IS OFTEN GOOD ADVICE.

Oh, how we want to tell people off when they hurt us! They bark and we bark back. They sting with words, and we join in the game, adding insult to injury. Only one problem. . .we're creating an ever-growing fire. Biting your tongue is tough, but in the long run you will save yourself a lot of grief.

Day 164

HE'S STANDING AT
THE DOOR KNOCKING.

Life can get crazy. . .and loud! Some-
times we miss things because the noise
level is so high: phone calls, a knock
on the door, text messages. Today, God
wants you to know that He's standing
at the door of your heart, knocking.
Can you hear Him? He wants to come
in and spend time with you.

Day 165
IT'S OKAY TO BE YOURSELF.

We live in a day of copycats. Everyone wants the same phone, the same car, the same television, the same Blu-Ray player, the same gaming system, the same clothing styles, the same type of house. Instead of fighting to be like everyone else, just relax. Be yourself. There's truly no better person you could be.

Day 166
YOU CAN BE A FRUIT-BEARER.

Some days we're more productive than others. We drop into bed at the end of the night feeling satisfied that we've put in a good day's work. However, even on the days when we're not physically able to keep up, we can still be productive by bearing fruit. What fruit, you ask? Love, joy, peace, patience. . . You get the idea!

Day 167
YOUR CIRCLE OF FRIENDS DOESN'T DEFINE YOU.

Think back to your junior high days. Remember how you wanted to fit into a certain group of friends? Oh, if only you were cool enough to hang out with them! Today, God wants you to know that who you know—who you hang out with—doesn't define you. It's who you are when you're all alone that matters.

Day 168
TO ERR IS HUMAN;
TO FORGIVE. . .DIVINE!

We all make mistakes. Some seem bigger than others (and some affect more lives). We want people to overlook our mistakes but don't always repay the favor. We hold grudges. We refuse to forgive. God's message of the day is this: Forgive. Let it go. This is your day to move forward.

Day 169
ACTIONS REALLY DO SPEAK LOUDER THAN WORDS.

What we say and what we do have to match. We can't say we're going to do something and then walk away and forget about it. God wants us to be people of integrity—people who do what they say and people who are who they claim to be.

Day 170
GUARD YOUR WORDS.

Remember that old saying "Sticks and stones may break my bones, but words will never hurt me"? It's not true. Words can cause deep, lifelong wounds. Today, God longs for you to guard your words. Don't wound.

Day 171
YOU ARE POWERFUL IN HIM.

If you've ever worked out at a gym, then you know what it's like to be aware of your strength. The more you work out, the greater the muscle mass, the more you can lift. Progress comes over time. The same is true of our relationship with the Lord. The more time we spend with Him, the stronger we get!

Day 172
WE FIGHT BEST ON OUR KNEES.

Some people fight it out in a court-
room. Others duke it out in a boxing
ring. Some quarrel with words, send-
ing emails back and forth across the
web. Today, God wants you to know
that the greatest way to fight is on
your knees. . .in prayer.

Day 173
YOU DON'T HAVE TO
GIVE IN TO TEMPTATION.

Too often we give in to the temptation to eat the wrong thing, say the wrong thing, do the wrong thing. . . without even fighting. You don't have to give in. Look that temptation in the eye and just say no!

Day 174

THE LORD WANTS YOU TO BE HIS HANDS AND FEET.

Ever feel like you need to be doing something for the Lord? Maybe you're so overwhelmed at all of the good things He's poured out on you that you want to give back. You can! With your hands, reach out to people in need. With your feet, walk toward the needy.

Day 175
YOU WERE MADE FOR GOOD WORKS.

The Bible is clear that we don't win special favors with God by behaving. However, He did create us to do good things. We don't do them to win brownie points or to earn a bigger eternal score. We do them because we're created in the image of God, the greatest good deed doer of all time!

Day 176

GOD WILL LIFT YOU OUT OF THE PIT.

Ever feel like you've fallen to the bottom of a deep pit? Like you're surrounded by darkness? Like there's no way out? Today, from the depth of your soul, cry out to God. His greatest desire is to lift you from that pit.

Day 177

HE IS WORTHY OF
ALL YOUR PRAISE.

We are often painfully aware of our unworthiness. We mess up, then slink away into the shadows, feeling like the scum of the earth. Even when we're in our lowest state, God is still worthy of our praise. He's not waiting until you get your act together; He wants to meet you today.

Day 178

THE ONLY WAY TO BE FILLED
IS TO EMPTY YOURSELF.

Do you ever cry out, "I just feel so empty inside!" If so, then you're in the perfect place for God to fill you up—with His joy, His laughter, His courage.

Day 179
SOUL FOOD IS ALWAYS ON THE MENU.

Before we can take care of others, we must take care of ourselves. This is especially true of our heart, mind, and soul. Feed yourself daily from the Word of God to satisfy your soul.

Day 180
IT'S BETTER TO OFFER LOVE THAN CRITICISM.

We have a tendency to offer critique even when the person we're critiquing doesn't expect it. Next time you feel that nudge, try offering words of love instead.

Day 181
HE'S STILL A MIRACLE-WORKING GOD.

Some are of the mindset that God is no longer in the miracle-working business. . .that all miracles ceased with the death of the last apostle. It's not true! Today, God wants you to know that He's still in the miracle-working business!

Day 182

HIS STRENGTH IS MADE PERFECT IN YOUR WEAKNESS.

When we are at our weakest, God is at His strongest. So don't be afraid to admit your weakness! It is in that very moment that God's strength is made perfect inside of you.

Day 183

A BEND IN THE ROAD IS
NOT THE END OF THE ROAD.

Oh, how we wish we could see all the way down the road. Fears kick in when we can't see around the bend. We imagine the worst. Today, God wants you to know that the bend in the road doesn't have to be a fearful place. It's not the end of the road; it's just a place where you can learn to trust Him more.

Day 184

MANAGING YOUR TIME WELL IS ESSENTIAL TO SUCCESS.

The ability to concentrate and to use your time well is everything if you want to succeed in business—or in anything else, for that matter.

LEE IACOCCA

Day 185

YOU CAN CALL ON HIM 24/7.

Have you ever arrived at a store just as it was closing for the day? If so, then you know the disappointment of "almost" making it. You'll never have an "almost" encounter with God. No matter when you call on Him, He will be there.

Day 186

YOU DON'T HAVE TO WORK TO EARN HIS LOVE.

Remember when you were a kid and your parents kept a "chore chart" on the wall? You got a check mark for making your bed, another check mark for keeping your room clean, and another for folding your clothes. Thank goodness God doesn't work off of the same system. Even if there are no "checks" on your chart, He loves you just the same!

Day 187
GOD WILL SET YOUR FEET UPON A ROCK.

Ever feel like you're slip-sliding along? Like you're wading in quicksand? Today, God wants you to know that He can set your feet on a rock (a solid place).

Day 188

YOU HAVE A SHELTER FROM LIFE'S STORMS.

Where do you run when it's storming? To the nearest shelter of course! Life presents us with many storms, and we run to all sorts of crazy places trying to find shelter. There's only one place that makes sense, however. Run straight to the Lord. He's the ultimate storm shelter!

Day 189
HE LONGS TO SPEND TIME WITH YOU.

If you've ever been in love, then you know what it feels like to yearn for someone. To pine for them. To count the hours until you see them again. Did you know that God is pining for you right now? It's true. He loves you that much!

Day 190

OPPORTUNITIES CAN BE GROWN INTO SOMETHING GREAT.

We're given hundreds of opportunities each year. Some make more sense than others. Today, God wants you to know that many of the opportunities He sends your way are going to grow (morph) into something far beyond what you ever expected. Prepare yourself for big things.

Day 191
THE BIBLE IS
YOUR ROAD MAP.

Are you navigationally challenged? Don't know north from south, east from west? Wish there was some sort of spiritual GPS to guide you? Good news. . .there is! God's Word is the best navigational tool you could ever use. It guides you straight into His arms.

Day 192
CHILDLIKE FAITH
IS A GOOD THING.

Isn't it wonderful to watch a small child leap into your arms? He's sure you'll catch him. No doubt about it, God wants us to approach Him with the same childlike faith—sure that He will not only catch us but lift us above our circumstances.

Day 193

THE OPINIONS OF OTHERS SHOULDN'T BOTHER YOU.

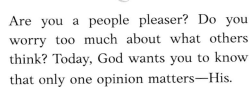

Are you a people pleaser? Do you worry too much about what others think? Today, God wants you to know that only one opinion matters—His.

Day 194
YOU CAN BE A
VOICE FOR TRUTH.

Who stands up for those who can't take a stand themselves? You can! That's right. . .you! Today, make up your mind to be a voice for truth. No, it isn't always popular. But you can rest your head on the pillow at night knowing you've made a difference in the world.

Day 195
YOU'VE GOT TO FACE THE CLOUD TO FIND THE SILVER LINING.

Likely you've heard the old expression "Every cloud has a silver lining." It's true. But it's time to face facts: You won't see the silver lining if you don't face the clouds. Stormy seasons will come. Don't run from them. If you look beyond the clouds, you'll see that shimmering lining.

Day 196

YOU DON'T HAVE TO CLAW YOUR WAY TO THE TOP.

These days folks scratch and claw their way up the corporate ladder, not really paying much attention to who they step on along the way. God wants you to know that He's in the "elevating" business. No need to step on anyone along the way. He will promote you when the time is right.

Day 197
YOU DON'T HAVE TO SEE YOURSELF AS A VICTIM ANYMORE.

Maybe you've been through some terrible experiences. You were abused as a child or badly wronged on the job. Here's the good news: that event does not define you. It's time to let go of the "victim" label. It's no longer yours because you've been set free.

Day 198

YOU CAN OVERCOME A HOT TEMPER.

Oy, that temper! It's like a pot of stew simmering on the stove. Any moment now, it could boil over! God wants you to grab hold of your temper, give it a firm shake, then send it packing. A calm, cool answer will go a lot further toward healing a relationship than an overspill!

Day 199

IT'S OKAY TO ADMIT
WHEN YOU'RE STRUGGLING.

So many of us pretend we're okay when we're really not. We put on a front, acting like we've got it all together. It would be better to open up and admit you're struggling. That way you're being completely honest and others will respond to your need.

Day 200

WHAT YOU DO IS NOT AS IMPORTANT AS WHO YOU ARE.

We put such stock in what we do, don't we? We brag about our careers, our aspirations, our over-the-top plans to make something of ourselves. Today, God wants you to know that what you do is good, but who you are is better. Be someone you can be proud of.

Day 201

YOUR LIFE IS A GIFT TO GOD.

What we are is God's gift to us. What
we become is our gift to God.

ELEANOR POWELL

Day 202
TAKING A SABBATH REST IS A GOOD THING.

Ah, sweet rest! After a long week, you're overdue for a break! God knows this and even set aside a special day just so you can kick your feet up and clear your head. Make sure you celebrate the Sabbath by kicking back and resting!

Day 203
GOD ANSWERS KNEE-MAIL.

We send all sorts of mail these days—snail mail, email, and even overnight mail. If you're looking for a sure answer, however, the best kind of mail you can send is knee-mail. Spend some time in prayer, and you will surely get your answer.

Day 204

THE LIGHT AT THE END OF THE TUNNEL IS NOT A TRAIN.

Have you ever felt like you were nearing the end of a chaotic period? Like you could finally see the light in the distance? Here's some good news: That light is not a train. It's a light that will guide you toward peace and fulfillment.

Day 205
DON'T FEAR THE OPINIONS OF OTHERS.

The moment we begin to fear the opinions of others and hesitate to tell the truth that is in us, and from motives of policy are silent when we should speak, the divine floods of light and life no longer flow into our souls.

ELIZABETH CADY STANTON

Day 206
GOD IS STILL IN THE HEALING BUSINESS.

It's true! God is the same—yesterday, today, and forever. If He did it for the mighty men and women in Bible days, He will do it for you. Today, you can believe God will heal you—heart, soul, and body.

Day 207
YOU ARE GOING TO MAKE MISTAKES.

You're not perfect. Face it. Like everyone else on the planet, you're going to make mistakes. Problem is, most people don't like to acknowledge their mistakes. Give yourself permission to mess up. Admit your flaws. There! Doesn't that feel good?

Day 208
ALL THINGS WORK TOGETHER FOR GOOD.

Sometimes it's hard to imagine that God could work all things together for good. After all, some of the things we go through are pretty awful. Some day we'll have the benefit of hindsight and will be able to see more clearly just how the Lord pieced all of our life experiences—good and bad—into one large, beautiful quilt.

Day 209
PACING YOURSELF IS A GOOD IDEA.

Go, go, go! What image does that sentence conjure up? Images of someone racing toward the goal, right? Today, the Lord wants you to know that pacing yourself is a better way to reach your goal. One foot at a time. One step at a time. Steady as she goes!

Day 210

LIFE IN THE SPOTLIGHT ISN'T ALL IT'S CRACKED UP TO BE.

Some people dream of making it big, of seeing their name up in lights. Unfortunately, life in the spotlight isn't always as thrilling as you might imagine. Today, make up your mind to step away from that tempting light.

Day 211
GOD DOESN'T MAKE MISTAKES.

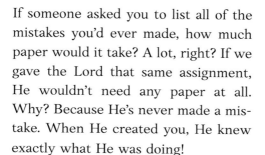

If someone asked you to list all of the mistakes you'd ever made, how much paper would it take? A lot, right? If we gave the Lord that same assignment, He wouldn't need any paper at all. Why? Because He's never made a mistake. When He created you, He knew exactly what He was doing!

Day 212
GOD CAN TURN LEMONS INTO LEMONADE.

Likely you've heard the old expression about turning lemons into lemonade. Some problems are so big, however, that it's hard to imagine turning them into something sweet. Thank goodness the Lord specializes in the impossible. He can turn even the roughest situation around.

Day 213

GOD IS IN THE LIFE-CHANGING BUSINESS.

Don't you love to see things renovated? Rooms, cars, people. . . it's so much fun to watch the transformation! Did you know that God is in the transforming business? Today, He longs to change your life for the better.

Day 214
MOST OF THE THINGS WE WORRY ABOUT ARE NOT ETERNAL.

Have you ever considered the fact that most of the things you worry about won't matter when you're in heaven? It's true! The daily trials and tribulations we go through in this life will soon be behind us. Eternity is forever. Problems are just for a season.

Day 215
GOD WANTS TO
RENEW YOUR STRENGTH.

Ever wished for a supernatural zap of strength? A burst of energy? Sometimes we're too weary to drum up the physical or emotional strength to keep going. Thank goodness God is standing nearby, ready to renew our strength when we need it most.

Day 216

YOU CAN HOLD ON A LITTLE WHILE LONGER.

Ever feel like you're hanging from a cliff, your fingertips about to lose their grip? Today, God wants you to know that you can hang on awhile longer. He's right there, holding your hands steady.

Day 217
YOU CAN'T OUTRUN GOD.

Many of us spend our lives running from things—obligations, relationships, even God. There are many things you can outrun, but no matter how fast you are, you can never outrun God. Today, why not turn and run toward Him instead of away?

Day 218

THE CLOCK IS NOT YOUR TASKMASTER.

Oh, how we let the clock rule us! It dictates our comings and goings and even our mood at times. It's time to say good-bye to that uncaring taskmaster! You can still keep up with appointments and plans, but they don't have to rule over you.

Day 219
THERE'S NO BUSINESS LIKE PRAYER BUSINESS.

We spend a lot of time thinking about our businesses—outside the home and in—but we don't often think of prayer as a "business." It is! In fact, it should be our primary business! Today, before you head off to work. . .get down to business!

Day 220
FITTING IN ISN'T ALL IT'S CRACKED UP TO BE.

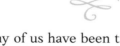

Many of us have been trying to "fit in" since childhood. Here's a great secret, one that would've been great to know in junior high: There's a huge difference between finding your fit and fitting in. Finding your fit is critical. Fitting in? Not so much.

Day 221

YOU CAN TURN YOUR WORRIES OVER TO GOD!

Every evening I turn my worries over to God. He's going to be up all night anyway.

MARY C. CROWLEY

Day 222

IT'S POSSIBLE TO PRAISE. . . EVEN IN THE STORM.

If you've been through a storm season, you know there is life on the other side of it. However, there's also life in the very midst of it. Even in the middle of the storm—when things are whirling around you—you can praise the Lord.

Day 223
YOU DON'T NEED TO WORRY ABOUT TOMORROW.

❧

When you hear the word *tomorrow*, what comes to mind? Are you unnerved, wondering what the future holds? Many people fear the unknown, wondering if it will be kind. Today, God wants you to know that you don't need to worry about tomorrow. He's going to be there with you.

Day 224
IT'S OKAY TO FAIL FORWARD.

If you've tried something but failed,
take heart! As long as you're failing in
the right direction, (forward) progress
is being made. Don't let one failure
stop you from trying again.

Day 225
GOD IS DOING A NEW THING.

Ever feel like your life is mundane? Each day is just the same old, same old? Well, there's good news today! Isaiah 43:19 tells us that God is doing a new thing! He stands by, ready to spring you into a world of new possibilities.

Day 226

WE ARE CREATED IN THE IMAGE OF A CREATIVE GOD.

Isn't it fun to think about what God was doing as He created the heavens and the earth? It's just as fun to think about the fact that we're created in His image. That means we're created to be creative too!

Day 227
GOD IS YOUR SOURCE.

If you've been relying on yourself to meet your needs (financial or otherwise), it's time for a reality check. You are not your source. No matter how great your job, how high your income, you're not the one responsible. God is your source, and He's got you covered!

Day 228
YOU CAN HEAR A
LOT IN THE SILENCE.

What a loud and crazy world we live in. Televisions blare, horns honk, people chatter, children argue, bosses lose their tempers. We're surrounded on every side. That's why it's important to step away from the noise as often as we can. You can hear a lot in the silence.

Day 229
THERE IS NO FEAR IN LOVE.

With love comes trust. With trust, fear vanishes. That's one reason it's so important to know that God loves you. You can trust His love. Resting in it means you have nothing to fear.

Day 230

YOU CAN STAND
ON GOD'S PROMISES.

If God said something, He will do it.
His promises are rock-solid. So solid,
in fact, that you can stand on them.
They're not going anywhere!

Day 231
CHARACTER MATTERS.

A good character is the best tomb-stone. Those who loved you and were helped by you will remember you when forget-me-nots have withered. Carve your name on hearts, not on marble.

CHARLES H. SPURGEON

Day 232
YOU CAN BATTLE
GIANTS AND WIN.

Up against a huge giant? Feel like you're small in comparison? There's good news! Like David facing the mighty Goliath, you can face your giants and win. With God's help, there will be victory!

Day 233
THINGS WILL GET BETTER.

Ever feel like you're on a downhill slide? Like things are progressively getting worse? Today, God wants you to know one thing: it will get better. No matter how tough things have been, your tomorrows are going to be better than your yesterdays.

Day 234
PRODIGALS ARE
WELCOMED BACK HOME.

If you've ever welcomed a prodigal child back into your home, you know the joy of reuniting with someone you thought you'd lost. In that same way, God welcomes us back when we've strayed. Why not run into His arms today?

Day 235
BEAUTY IS MORE THAN SKIN DEEP.

Some people are undeniably beautiful. They possess the faces and bodies you see on magazine covers. There's good news today! Even if you weren't blessed with physical beauty, you can radiate great beauty by letting your spirit shine. Beauty is definitely more than skin deep!

Day 236
GOD HAS AMAZING PLANS FOR YOU!

God's plans for us are better than we can imagine! Ephesians 2:10 says, "We are God's handiwork, created in Christ Jesus to do good works, which God prepared in advance for us to do." What an exciting future you have!

Day 237

IF A MILLION PEOPLE SAY A FOOLISH THING, IT'S STILL A FOOLISH THING.

Sometimes we spend so much time listening to so-called experts that we don't realize when they're wrong. Today, instead of being duped, ask for the Lord's opinion. He will never give you foolish advice.

Day 238

YOU MIGHT GO THROUGH HIGH WATERS, BUT YOU WILL NOT DROWN.

Ever feel like you need a life preserver to get through the high waters of life? It's true. . .we go through some deep places. How wonderful to know that the Lord is holding us up. The waters might rage around us, but we're not going down!

Day 239

GOD WOULD RATHER BE YOUR PILOT THAN YOUR COPILOT.

Handing over the controls of your life to the Lord might sound impossible, but He's got the flight plan memorized! He's also skilled at life flights. You can trust Him!

Day 240
GOD GAVE YOU A SOUND MIND.

Ever feel like your thoughts are cloudy? Like things don't make sense? Shake off those feelings. Don't give in to them. Remember the words of Isaiah 26:3: "[God] will keep in perfect peace those whose minds are steadfast, because they trust in you."

Day 241
YOU CAN FORGIVE EVEN WHEN YOU CAN'T FORGET.

Sometimes we're so deeply wounded that it leaves a lasting scar. Did you know it's possible to forgive even when the scars are visible? You might not forget, but forgiveness is a choice you can make. A tough choice, sure. . . but the right one.

Day 242

IF WE WORRY ABOUT TOMORROW, WE WILL MISS TODAY.

Sometimes we're so busy fretting over the unknown (tomorrow and beyond) that we miss the obvious: today! Take a deep breath. Look around you. Today is happening! Don't let it pass you by.

Day 243
YOUR CHILDREN ARE YOUR LEGACY.

Have you ever thought about what you will leave behind when you're gone? Many focus on leaving things like money, jewels, or houses. If you're a parent, the greatest gift you will leave the world is your children. They are your legacy, your inheritance.

Day 244
IT'S OKAY TO DREAM BIG.

Have you ever been accused of being a dreamer? Maybe some people think your goals or plans are unrealistic. Don't let that stop you! Today, God wants you to know that dreaming big is okay.

Day 245
GOD IS HOPELESSLY DEVOTED TO YOU.

Have you ever been so in love that you couldn't see straight? If so, then you have some indication of God's love for you. He's moon-eyed over you!

Day 246

WHO YOU ARE IS NOT
WHO YOU'RE GOING TO BE.

Today, God wants you to know that you don't have to settle for a mundane life. Don't buy the lie that you'll never "be" anything (or anyone) other than who you are today. Sure, there's a gap between who you are and who you could be. . .but it's a gap you can sail over!

Day 247

THE BIBLE IS MORE THAN A HISTORY BOOK.

The Bible is filled with amazing stories from thousands of years ago, but it's so much more than a history book. Each story is true and contains relevant, practical information to help you live your life in the twenty-first century.

Day 248

WE POSSESS POWER BEYOND MEASURE.

Our deepest fear is not that we are inadequate. Our deepest fear is that we are powerful beyond measure. . . . You are a child of God. Your playing small doesn't serve the world. There's nothing enlightened about shrinking so that other people won't feel insecure around you. We were born to make manifest the glory of God that is within us.

NELSON MANDELA

Day 249

YOU DON'T HAVE TO BE ASHAMED OF YOUR MISTAKES.

God never intended us to walk around, overwhelmed by shame. Once we experience His forgiveness, we can lift our eyes and our heads and face today (and tomorrow) with confidence, not held back by the mistakes of our yesterdays.

Day 250

GOD HAS GIVEN YOU POWER TO BRING ABOUT CHANGE!

Ever wish you could make a difference in the world? You can! Your attitude, your willingness to help those in need, your generous nature. . .all of these can play a role in bringing about change in your world. Make up your mind to be a change-maker!

Day 251

WORK IS MEANT TO BE ENJOYED.

Did you know that God never intended for your workday to be mundane or painful? Consider the words of Ecclesiastes 3:22: "So I saw that there is nothing better for a person than to enjoy their work, because that is their lot. For who can bring them to see what will happen after them?"

Day 252

A RELAXED STATE OF MIND IS A HEALTHY STATE OF MIND!

We can get so caught up in the anxieties of our work, our families, and our finances that we feel wound up all the time. Today, take a deep breath. Relax. Trust God. Only in that relaxed state can your body regenerate.

Day 253

YOU WERE CREATED IN THE IMAGE OF A CREATIVE GOD.

We are creative beings. We're always thinking of ways to use our creativity to enrich our lives. No need to apologize for that! We're created in the image of a creative God, after all!

Day 254
YOU DON'T HAVE TO FIGURE IT ALL OUT.

Ever feel like life is one big pop quiz that you're failing? Don't fret! It's not. You don't have to have all of the answers. God is a very forgiving teacher, and He grades on a grace-filled curve.

Day 255

YOU HAVE AN EVER-PRESENT HELP IN TIME OF NEED.

Do you ever wish you could just snap your fingers and a hero would come rushing in to save the day? You can. . . and He will! God is waiting for you to turn to Him with your problems and pain. He is your ever-present help in time of need.

Day 256

HE GIVES STRENGTH
TO THE WEAK.

Looking for the strength-building technique? The kind that invigorates you, even on the toughest of days? Isaiah 40:29 says that "[God] gives strength to the weary and increases the power of the weak." What great news!

Day 257

YOUR TOMORROW CAN BE BETTER THAN YOUR YESTERDAY.

Perhaps you've walked through a tough season in your life. If so, lift that chin! Look up! Just because you've been through a difficult time doesn't mean tomorrow is going to be difficult. Better days lie ahead. Face them with hope.

Day 258
YOUR PERSPECTIVE IS CRITICAL.

You can tell the size of your God by looking at the size of your worry list. The longer your list, the smaller your God.

<div align="right">UNKNOWN</div>

Day 259

YOU CAN BE A LIGHT IN THE DARKNESS.

Remember that song we used to sing as kids. . .the one about letting our little light shine? It is possible, even when you feel as if you're surrounded on all sides by darkness, to let your little light shine. You can make a difference in your workplace, your community, your home, and your country.

Day 260
EVERY DAY CAN
BE YOUR BEST DAY.

Do you look forward to each new day with great excitement? You would if you realized that every single day of the week has the potential to be your best day ever! Make up your mind to celebrate each day as a victory.

Day 261
HE SINGS OVER US.

This is hard to imagine, but God celebrates our existence. It's true. According to Zephaniah 3:17, " '[He] will rejoice over you with singing.' " Today, the Lord wants you to imagine Him doing the happy dance overhead while you celebrate His goodness here below.

Day 262

YOU CAN MAKE SOMEONE'S DAY SPECIAL WITH YOUR KINDNESS.

Isn't it amazing how a kind word—just a simple compliment or hello—can make someone's day? Today, make a point to reach out to someone with a smile, a cheerful greeting, or a flattering comment.

Day 263
EVERYBODY FALLS SOMETIMES.

Life provides plenty of opportunities to trip and fall, doesn't it! Falling isn't the problem. Staying down is. When you fall—and you will—do your best to bounce back up again. Remember, you're not alone. We all fall. But it takes a resilient person to get back up and begin again.

Day 264

YOU ARE A NEW CREATION. THE OLD HAS PASSED AWAY.

Have you ever watched a plant—nearly dead—spring back to life again with water and sunshine? If so, then you've witnessed the miracle of rebirth. The plant is like new. Today, God wants you to know that the same rebirth is possible in your life. Allow Him to make you brand new.

Day 265
HIS PAIN IS YOUR GAIN.

If you're an exercise fanatic, then you surely know these words: "No pain, no gain!" It's true, isn't it! However, when it comes to the Lord, He took the pain for you. His pain—the sacrifice of His Son—is definitely your gain!

Day 266

EXPRESSING YOUR GRATITUDE IS A GOOD THING.

The more we express our gratitude to God for our blessings, the more He will bring to our mind other blessings. The more we are aware of to be grateful for, the happier we become.

EZRA TAFT BENSON

Day 267
WHAT YOU DO MAKES A DIFFERENCE.

Maybe you feel like you're just one teensy-tiny person in a giant world filled with billions of people. You think you can't make a difference. Not true! You were put on this planet to make a difference. Don't ever be convinced otherwise.

Day 268

MONEY DOESN'T HAVE TO CONTROL YOU.

What do you think of when you hear the words "the daily grind"? Do you picture yourself slaving away to earn a few bucks to pay the mortgage, light bill, and so on? We need to take a vacation from this sort of thinking. Money is just a means to an end. It's not our boss. We can trust God even with our finances.

Day 269

THERE WILL BE ANSWERS IN HEAVEN TO THE "WHY" QUESTIONS.

So many things happen in this life that we don't understand. We can't make sense of them, no matter how hard we try. And asking "why" only gets us more confused. Today, God wants you to know that the "why" questions will be answered in heaven, where there are no more tears and no pain.

Day 270

THERE IS ROOM IN THE FAMILY FOR YOU.

Maybe you grew up in a family where you felt as if you didn't fit in. Perhaps those feelings have spilled over as you've considered joining a local church. Don't be afraid! There's plenty of room in the family for you!

Day 271
GOD WILL MAKE YOUR PATH STRAIGHT.

Ever feel like the road stretched out in front of you is jagged and confusing? You're not sure which way to go? Even if the path appears to be crooked, God can—and will—clarify which way to go. Trust Him each step of the way.

Day 272

A FOOL AND HIS MONEY ARE EASILY PARTED.

Spending frivolously is such a temptation, particularly if you're an impulse shopper. After all, you can blow a lot of money in a hurry when you're not paying attention! This would be a good day to s-l-o-w down. Don't part with that money so quickly. Think it through.

Day 273
WE LEARN BY TRIAL AND ERROR.

We're on a never-ending learning curve. We make mistakes, correct them, then try again. Sometimes it takes several tries to get it right. That's okay! Just don't give up. Keep on keepin' on, even if you make a few mistakes along the way.

Day 274
NATURE SINGS GOD'S PRAISES.

If God had wanted to be a big secret,
He would not have created babbling
brooks and whispering pines.

ROBERT BRAUL

Day 275
GETTING IN SHAPE CAN BE FUN.

Remember when you were a kid in gym class? What fun you had, running laps and doing jumping jacks. Working out is still fun as long as you have a good attitude. Stay in shape, both mentally and physically!

Day 276
NO ONE ELSE IS LIKE YOU.

Maybe you've heard the old expression "When God made you, He broke the mold!" It's true! You are unique. You're different. . .and that's a good thing. Today, God wants you to celebrate your uniqueness!

Day 277
IF GOD SAID IT, IT'S SO!

We can't always trust people. They say they're going to do things. . .then don't. Today, God wants you to know that you can trust Him. If He said it, it's so!

Day 278

YOUR SECURITY DOESN'T LIE IN YOUR OWN ACCOMPLISHMENTS.

Perhaps you're very accomplished—a great worker, skilled at what you do. Even so, your security doesn't lie in your performance. Even the best performance doesn't come close to what God can do through you.

Day 279
GOD'S TIMING IS PERFECT.

Sometimes we question God's timing. We wonder why He waits till the eleventh hour to work a miracle and/or pull us through a rough situation. Here's a newsflash: God's timing is perfect. He's never late.

Day 280

GOD MAKES HIMSELF
KNOWN EVERY DAY.

People see God every day, they just don't recognize Him.

PEARL BAILEY

Day 281
CONFESSION REALLY IS GOOD FOR THE SOUL.

It's true! No matter what you've done—good or bad—you'll feel better if you tell someone. Today, if you've been harboring something deep inside of you, open up and share it with someone you can trust.

Day 282

GOD HAS CALLED YOU BY NAME. YOU ARE HIS!

Remember when you were little and your mom wanted your attention? If you came from a large family, she likely called out the names of your brothers and sisters before getting your name right. There's good news today: God has called you by name! He doesn't get you mixed up. You're His precious child!

Day 283
LIFE IS A GREAT TEACHER.

If someone asked you to make a list of all the lessons you've learned in your lifetime, could you do it? Probably not! Life presents us with an opportunity to learn on a daily—if not hourly—basis. Life. . .the best teacher!

Day 284

YOUR LIFE CAN PREACH A BETTER SERMON THAN ANY WORDS.

Sometimes our actions don't match the words coming out of our mouth. It's never good to say one thing and do another. People are watching how you live, not so much what you say. Today, make up your mind to preach a great sermon with your life.

Day 285

GOD CAN HEAL A BROKEN HEART.

Imagine a broken glass, shattered into dozens of pieces. Even the best glue in the world couldn't piece it back together. Sometimes our hearts are as broken as that glass. We think that we'll have to live in a state of brokenness. . .forever. Oh, but it's not true! God is in the heart-mending business!

Day 286
YOUR HAIRS ARE NUMBERED.

Did you know that God knows how many hairs are on your head? It's true! If He knows that much about you, then surely He cares about you very much!

Day 287

IT IS POSSIBLE TO GET RID OF A HARD HEART.

Ever feel like you've been so badly wounded by someone that your heart is hard? Crusty? Unbending? Even if you've felt this way a long time, there's good news today. God knows just how to breathe life into your hard heart, making it soft and pliable once again.

Day 288
CHALLENGES GROW US.

Imagine a little flower, beaten down by the rain. When the sun comes out, however, the flower perks up, energized by the moisture it received during the downpour. Maybe you can relate. Life's challenges (downpours) can make us feel defeated. Thank goodness they're sent to help us grow!

Day 289

GOD'S WAYS ARE HIGHER THAN OUR WAYS.

God is not what you imagine or what you think you understand. If you understand you have failed.

SAINT AUGUSTINE

Day 290

THE MORE YOU SEEK HIM, THE MORE YOU'LL FIND HIM.

God is always standing nearby, ready to respond to your call. He's not hiding from you. The more you look for Him (on a daily basis), the more aware you will be of His presence.

Day 291
YOUR PRAYERS ARE POWERFUL.

Remember Popeye? What gave him the strength he needed to get through his challenges? Spinach, of course! Prayer is the "spinach" we need to pull through life's struggles. It's the most powerful weapon we have!

Day 292

IT'S TIME TO REVIEW YOUR PURPOSE IN LIFE.

Life without a purpose is a languid, drifting thing; every day we ought to review our purpose, saying to ourselves, "This day let me make a sound beginning."

THOMAS À KEMPIS

Day 293
ONE ON GOD'S SIDE
IS A MAJORITY.

If you've ever been ganged up on, then you know the pressure of having majority opposition. God wants you to know that He's on your side, and with Him, you're always in the majority!

Day 294

YOU DON'T HAVE TO BE RIGHT ALL OF THE TIME.

Ouch! What? You mean I don't get to be right all of the time? The answer—and it's a healthy answer—is no. You're only right. . .when you're right. Sometimes (gasp!) you're wrong. Admitting it is a good thing.

Day 295
EVERY ENDING IS A NEW BEGINNING.

So many times we grieve the ending of something—a job, a school year, a relationship—thinking the best is behind us. Not true! Remember, every ending is a new beginning!

Day 296
SOME QUESTIONS CAN'T BE ANSWERED ON THE INTERNET.

Some of life's most difficult questions will never be answered on the Internet. In fact, some of them won't even be answered in this lifetime. We will only know the answer in heaven. Likely, by then, the answers to those tough questions won't matter anymore.

Day 297

YOU DON'T HAVE TO LET ANXIETY WEIGH YOU DOWN.

Did you know that anxiety is a choice? It's true! Worry about tomorrow is never a good idea. It gets you bound up on the inside. God longs for you to release that anxiety. Let it go. There! Doesn't that feel good?

Day 298
YOU CAN BE FILLED WITH OVERFLOWING JOY.

Have you ever overfilled a glass with water, tea, or coffee? If so, then you know what the word "overflowing" means. God wants you to be filled with "overflowing" joy today, despite any circumstances you might be walking through.

Day 299
YOU CAN REAP WHAT YOU SOW.

It's just common sense. You reap what you sow. If you sow kindness, love, and gentleness, you will (eventually) reap it. If you sow bitterness, anger, and frustration, it will swing back around to meet you. No doubt about it!

Day 300

THE MOST IMPORTANT THINGS IN LIFE AREN'T THINGS.

How we love our stuff! Cars, the latest and greatest telephones, computers, and so on. They're so important to us. Sometimes our "things" are too important. We have to remember that the people God has placed around us are far more important than anything we can acquire.

Day 301
GOOD DEEDS OFFER A GREAT RETURN.

If you've ever invested money, then you know what the words "good return" mean. You invest a certain amount but receive even more as a result. The same is true with good works. When you're good to others, those good deeds come back around to meet you!

Day 302
GOD WILL USE YOU IN WAYS YOU'VE NEVER DREAMED OF.

What if you could see into the future? You might be stunned to see that God is going to use you in some miraculous way to reach out and touch someone you haven't even met yet. No matter how big our dreams are, God's dreams for us are greater still!

Day 303

THE LORD WANTS TO ENLARGE YOUR VISION OF WHO HE IS.

When I look at the galaxies on a clear night—when I look at the incredible brilliance of creation, and think that this is what God is like, then instead of feeling intimidated and diminished by it, I am enlarged. . .I rejoice that I am a part of it.

MADELEINE L'ENGLE

Day 304

IT'S NOT WHAT YOU HAVE IN YOUR LIFE, IT'S WHO YOU HAVE IN YOUR LIFE.

Some people spend their whole lives accumulating stuff—houses, cars, televisions, computers, etc. Today, the Lord wants to remind you that it's about the people not the stuff.

Day 305

IF YOU STAND FOR NOTHING, YOU'LL FALL FOR ANYTHING.

Taking a stand for what you believe in takes a lot of fortitude and doesn't always win popularity contests! It's time to stiffen that backbone! Even if it's hard, take a stand.

Day 306

HE IS YOUR PEACE, WHO HAS BROKEN DOWN EVERY WALL.

Today, God wants to remind you of the words of Ephesians 2:14: "For he himself is our peace, who has made the two groups one and has destroyed the barrier, the dividing wall of hostility." No more walls!

Day 307

GOD'S PROMISES SHINE LIKE STARS.

God's promises are like the stars; the darker the night the brighter they shine.

DAVID NICHOLAS

Day 308
HE WILL BE A FATHER
TO THE FATHERLESS.

Whether your earthly father played an active role in your life or not, God still longs to prove Himself to be the ultimate Father, one you can trust. Consider the words of Psalm 68:5, "A father to the fatherless, a defender of widows, is God in his holy dwelling."

Day 309

YOUR STORY IS GOING TO END WELL.

Imagine your life story was written down in a book. Would you wonder about the yet-unwritten chapters? This should bring you peace of mind: You could glance ahead to the ending and find that everything ends well. God has you in His care. Your story is a happily-ever-after one!

Day 310

GOD CAN HANDLE WHATEVER YOU THROW HIS WAY.

Those who never rebelled against God, or at some point in their lives shaken their fists in the face of heaven, have never encountered God at all.

CATHERINE MARSHALL

Day 311
OVERLOOKING AN INSULT SHOWS WISDOM.

When we're offended, we often knee-jerk or return insult for injury. It takes a lot more wisdom (and patience) to turn the other cheek. May this day's reactions be an example for others and an opportunity to show great wisdom.

Day 312
YOU CAN LISTEN TO LIFE.

The purpose of life is to listen—to yourself, to your neighbor, to your world, and to God and, when the time comes, to respond in as helpful a way as you can find. . .from within and without.

FRED ROGERS

Day 313

YOU ARE BEING MOLDED AND SHAPED INTO SOMETHING BEAUTIFUL.

Ever wish you could predict the future? Wish you could see what sort of person you'll turn out to be? Well, rest easy! God is busy at this very moment, shaping you into something—and someone—of great beauty!

Day 314

EVEN WHEN YOU CAN'T TRUST PEOPLE, YOU CAN TRUST GOD.

People have a tendency to let us down, don't they? Sometimes betrayal runs deep. God is good! He's never going to let you down. You can trust Him implicitly!

Day 315

GOD ISN'T LOOKING
FOR AN ADVISOR.

Most people wish to serve God—but
only in an advisory capacity.

UNKNOWN

Day 316

TO THOSE WHO BELIEVE,
ALL THINGS ARE POSSIBLE.

Maybe you're facing something so challenging that fear has you wrapped in its grip. Today, God wants you to trust in the words found in Mark 5:36: "Don't be afraid; just believe." Lay down that fear. . .and believe.

Day 317
WHEN YOU LOVE, YOU GIVE.

There's something about love that makes us generous. When we love someone, we want the best for them. Sometimes that means reaching deep into our pocketbooks to care for unexpected needs. Sometimes it means giving to the poor or needy. Be prepared! When you love. . .you give.

Day 318

HE WILL NOT LEAVE
YOU COMFORTLESS.

Have you ever been so emotionally spent that comfort seemed impossible? Even when you're in intense pain, God can—and will—wrap you in His arms. His Spirit breathes new life into your heart, easing the pain and cocooning you in His love.

Day 319

YOU WERE CREATED TO
MAKE A JOYFUL NOISE.

Maybe you're not a vocalist. You can't carry a tune in a bucket. That shouldn't stop you from praising God with a song. Follow the instruction in Psalm 98:4: "Shout for joy to the LORD, all the earth, burst into jubilant song with music."

Day 320

HE IS PREPARING A PLACE FOR YOU.

Did you know that God has a special place in heaven for you? When this life is over, you can walk streets of gold, live in a heavenly mansion, and dance past gates of splendor. How wonderful, to imagine God up in heaven, getting it all ready. . .just for you!

Day 321
LIFE IS A CANVAS.

Isn't it fun to think about your life like a large canvas? Already the Master Artist has painted some vibrant colors. The fun part? Imagining what colors are yet to come.

Day 322
BEING FORGIVEN DOESN'T MEAN YOU'RE PERFECT.

Some people really struggle with the need for perfection. Rest easy! God doesn't expect perfection. He longs for you to do your best and to walk in relationship with Him. But when you mess up—and you will—He stands nearby, ready to forgive.

Day 323

HANGING OUT WITH LIKEMINDED PEOPLE IS FUN!

It's always great to find a group of likeminded people, isn't it? When you hang out with people with similar interests and beliefs, you can relax and be yourself. If you're looking for a safe place to spend time with new friends, check out the churches in your area. They're loaded with awesome people . . .just like you!

Day 324
YOU CAN DO SOMETHING.

I am only one, but still I am one. I cannot do everything, but still I can do something; and because I cannot do everything I will not refuse to do the something that I can do.

EDWARD EVERETT HALE

Day 325
YOU DON'T NEED TO TAKE YOURSELF SO SERIOUSLY.

Some people are far too concerned about the little details of their life—the tiny mistakes, and so on. It's time to lighten up! Don't take yourself so seriously. Not everything is a huge deal. In fact, most of the things we fret over today will mean nothing tomorrow.

Day 326
FRIENDSHIPS REQUIRE CULTIVATION.

A friendship can weather most things and thrive in thin soil; but it needs a little mulch of letters and phone calls and small, silly presents every so often—just to save it from drying out completely.

PAM BROWN

Day 327
YOU CAN BE A SEED PLANTER.

When you influence the lives of those around you, you're leaving behind tiny seeds that will blossom long after that person moves on. Seeds of hope. Seeds of joy. Seeds of encouragement. Today, plant some lovely seeds in someone you meet.

Day 328
RISK OR RASH?

There's a huge difference between taking a risk—stepping out in faith—and acting in a rash manner. Life is filled with risks. Just face them with common sense.

Day 329
EXCELLENT ADVICE!

It was a high counsel that I once heard given to a young person, "Always do what you are afraid to do."

RALPH WALDO EMERSON

Day 330
THE NUMBER ON THE SCALE DOES NOT DEFINE YOU.

We let so many things define us—our job, our talents, our family, our peers, our coworkers. . .even our weight. Whether you're chubby, thin, tall, short, or in-between, you can't be ruled by how you look or how much you weigh.

Day 331

YOU CAN FEED YOUR FAITH AND STARVE YOUR DOUBTS.

Sometimes we get in a rut where our faith is concerned. After all, it's easier to get down about something than to invest the time hoping and believing things will turn around in our favor. Today, God wants you to start feeding your faith. When you do, it will grow, grow, grow!

Day 332

YOU CAN BE A WITNESS.

Sometimes being a good witness is as simple as not giving in to temptation. Even if others around you are setting a bad example for their peers—you can stand out in the crowd by doing the right thing.

Day 333
LOVE MAKES YOU BEAUTIFUL.

Have you ever noticed that people who are physically unattractive appear beautiful when they're in love? There's a beauty that radiates from the inside out. Likewise, even the prettiest person can seem ugly when love is lacking. Which would you rather be—lovely on the inside or the outside?

Day 334

WHEN GOD DISCIPLINES US, IT'S BECAUSE HE LOVES US.

Most parents know that discipline is a natural part of raising children. We don't discipline out of anger but rather to see the child grow and mature into a responsible adult. Did you know that God sometimes disciplines His kids too? Don't let that news discourage you though. He's the most loving parent ever!

Day 335
GOD WILL STRENGTHEN YOU.

God says, "Do not fear, for I am with you; do not be dismayed, for I am your God. I will strengthen you and help you; I will uphold you with my righteous right hand" (Isaiah 41:10).

Day 336
GOD SPECIALIZES IN THE IMPOSSIBLE.

Doesn't it encourage you to know that nothing is impossible for God? If you've ever spoken the words "It would take a miracle," then take heart! You happen to know Someone who's in the miracle-working business. He delights in the impossible, in fact!

Day 337
HAPPILY-EVER-AFTERS DO HAPPEN.

Maybe you've been wounded by some-
one who claimed to care about you.
Perhaps your relationship didn't end
well. Today, God wants you to know
that He's got a real (eternal) happily-
ever-after planned out for you. Check
it out in the Bible. The Prince really
does come on a white horse, after all!

Day 338

GOD SPEAKS TO US IN EVERYDAY OCCURRENCES.

Every happening, great and small, is a
parable whereby God speaks to us, and
the art of life is to get the message.

MALCOLM MUGGERIDGE

Day 339
TAKING CARE OF YOUR BODY IS IMPORTANT.

When we come to understand that our bodies are temples, we realize the importance of caring for them! 1 Corinthians 6:19–20 says, "Do you not know that your bodies are temples of the Holy Spirit, who is in you, whom you have received from God? You are not your own; you were bought at a price. Therefore honor God with your bodies."

Day 340
GOD LOVES CHATTING WITH YOU.

Do you have a good friend, someone you love chatting with? God calls you His friend, and He loves spending time with you in one-on-one conversation. Today, stop what you're doing and settle in for a long chat.

Day 341

GOD MISSES YOU WHEN YOU DON'T SPEND TIME WITH HIM.

It's hard to imagine God longing for time with His kids, isn't it? You would think He'd be so busy running the world that He wouldn't notice if we missed a few days of hanging out with Him. He's never too busy to spend time with His kids, so crawl up in His lap today.

Day 342

LIVING FOR TODAY
IS A GREAT IDEA.

With the past, I have nothing to do;
nor with the future. I live now.

RALPH WALDO EMERSON

Day 343
GOD LONGS TO SET THE PRISONERS FREE.

Ever feel trapped? Feel like something has you imprisoned? There's good news today! No matter what has you bound, God longs to set you free! Give it to Him, and watch those prison doors swing wide open.

Day 344
LIFE IS AN AMAZING RACE.

Sometimes life feels like an actual race, doesn't it? You come charging out of bed in the morning. You race to the office, other workers buzzing by you (some appearing to pass you by). You arrive home (the finish line) exhausted. Deep breath, runner. This life is meant to be enjoyable. Not exhausting!

Day 345
AVAILABILITY IS
BETTER THAN ABILITY.

Sometimes we limit ourselves because we claim we're lacking in the "ability" department. We feel inadequate. There's good news today! God wants you to know that making yourself available to be used is far more important than your ability!

Day 346
GOD CAN'T ALTER THE PAST.

The past is in the past. Perhaps you wish you could change it. Unfortunately —or fortunately—there's no going back. The past can't be altered. Instead of focusing on it, however, it's time to live in today. Today, you have the opportunity to do the things you wish you'd done in the past.

Day 347
GOD LOVES YOUR FAMILY.

If you've ever worried about a family member—maybe someone who's struggling to get by or perhaps one who's made poor decisions—remember this: God loves your family even more than you do. He's watching over them even now.

Day 348

AFRAID? DO IT ANYWAY.

"For I am the LORD your God who takes hold of your right hand and says to you, Do not fear; I will help you."

ISAIAH 41:13

Day 349

LAUGHTER IS A SMILE WITH THE VOLUME TURNED UP.

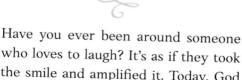

Have you ever been around someone who loves to laugh? It's as if they took the smile and amplified it. Today, God wants you to know that you don't have to shy away from laughter. Let 'er rip!

Day 350
IT'S POSSIBLE TO STAND
EVEN WHEN OTHERS ARE FALLING.

Maybe you're watching your friends tumble one after the other. They're giving in to temptation. Doing things that could destroy their lives. Just because they're falling doesn't mean you have to. Take a step back if you need to, but keep on standing.

Day 351
APATHY IS NEVER
A GOOD THING.

Science may have found a cure for most evils; but it has found no remedy for the worst of them all—the apathy of human beings.

HELEN KELLER

Day 352

GOD IS THE MENDER
OF BROKEN HEARTS.

So many times in life we end up broken-hearted. Romantic relationships end. Friendships are torn apart. We're hurt—psychologically or emotionally—by a boss who is only thinking of the company. Today, take that broken heart and give it to the Lord, who longs to mend it with His love.

Day 353

HE'S WATCHING OVER HIS WORD TO PERFORM IT.

Ever wondered if God is going to do what He promised in the Bible He would do? He answers that question Himself in Jeremiah 1:12 when He said: "I am watching to see that my word is fulfilled."

Day 354

YOU SHOULDN'T BORROW SORROW FROM TOMORROW.

Maybe you're facing something really sad—a friend is dying, your finances are dwindling, your job situation appears to be ending. Instead of focusing on the potential sadness of tomorrow, hang tight to today. There are great blessings in the here and now. Don't miss them!

Day 355

HOPE IS A PRECIOUS COMMODITY.

Ever wish you had a hidden stash of gold or silver? Both metals are precious and worth a lot of money. Did you ever think about the fact that hope is precious too? In some ways, it's more valuable than gold or silver because it has the capability of energizing you for the tasks ahead.

Day 356
YOU ARE AN INVENTOR!

We are all inventors, each sailing out on a voyage of discovery, guided each by a private chart, of which there is no duplicate. The world is all gates, all opportunities.

RALPH WALDO EMERSON

Day 357
DEBT-FREE LIVING IS A GOOD THING.

It's easy to get trapped into thinking we deserve the best of everything . . .and we deserve it now! A bigger house, a more expensive car—we're willing to mortgage ourselves to the hilt to have what we want. Today, God wants you to know that He longs to loose you from the chains of debt.

Day 358

IF GOD IS FOR US, WHO CAN STAND AGAINST US?

Ever feel outnumbered? Like you're surrounded on all sides? You are never alone, even in the middle of the battle. With God on your side, thousands could stand against you, but they would all come out losers in the end.

Day 359

GOD LONGS TO PUT THE BROKEN PIECES TOGETHER.

Man is born broken. He lives by mending. The grace of God is glue.

EUGENE O'NEILL

Day 360

IF YOU AIM AT NOTHING, YOU WILL SURELY HIT IT.

Imagine you went to the shooting range to practice only to discover all the targets had been removed. You would have nothing to aim at. How often do we go through life with no aim? We wander with no sense of direction, then wonder why we feel lost. Today, set your aim! Find the target. Then, go for it!

Day 361

YOU REALLY CAN DO THE THING YOU'RE AFRAID OF.

Ever been challenged to do something difficult? Something that really frightened you? Maybe you stopped just shy of doing it. Fear wrapped you in its tentacles. Today, God wants you to know that, with His help, you really can do the very thing you're afraid to do.

Day 362
WE SERVE A MERCIFUL GOD.

If you feel like you've really messed up—like you can't possibly hang out with God because of something you've done—think again! Psalm 103:8 shows us that "The Lord is compassionate and gracious, slow to anger, abounding in love." What great news!

Day 363

GIVE AND TAKE:
IT'S ALL IN THE ATTITUDE.

Blessed are those who can give without remembering and take without forgetting.

ELIZABETH BIBESCO

Day 364
OPPORTUNITIES ABOUND.

Each new day presents countless opportunities: to do unto others as you would have them do unto you. To forgive. To praise your way through tough times. To make good choices. Opportunities for goodness abound!

Day 365
GOD LOVES IT WHEN YOU COUNT YOUR BLESSINGS.

Count your blessings. Once you realize how valuable you are and how much you have going for you, the smiles will return, the sun will break out, the music will play, and you will finally be able to move forward with the life that God intended for you with grace, strength, courage, and confidence.

OG MANDINO

NOTES

NOTES

NOTES

NOTES

NOTES

NOTES

NOTES

NOTES

NOTES

NOTES

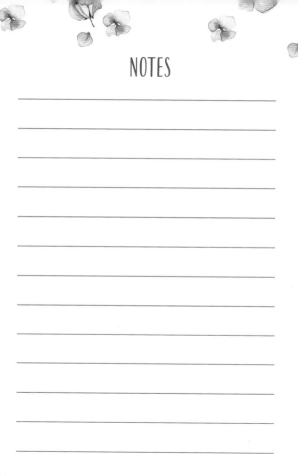

NOTES

NOTES

LOOKING FOR MORE 60-SECOND REFRESHMENT?

Daily Wisdom for Women

You'll love the power-packed insights in this simple daily devotional. Each bite-sized reading focuses on real, relatable topics like prayer, God's promises, blessings, salvation, purpose, and many more.

Hardback / 978-1-64352-334-7 / $12.99

Power Prayers for Women

You'll love the power-packed insights in this simple daily prayer devotional. Each day's entry includes a personal, thoughtful prayer that's readable in about a minute.

Hardback / 978-1-64352-763-5 / $12.99